— THE —
CANADIAN ROCKIES

A COMPLETE PHOTOGRAPHIC PORTRAIT

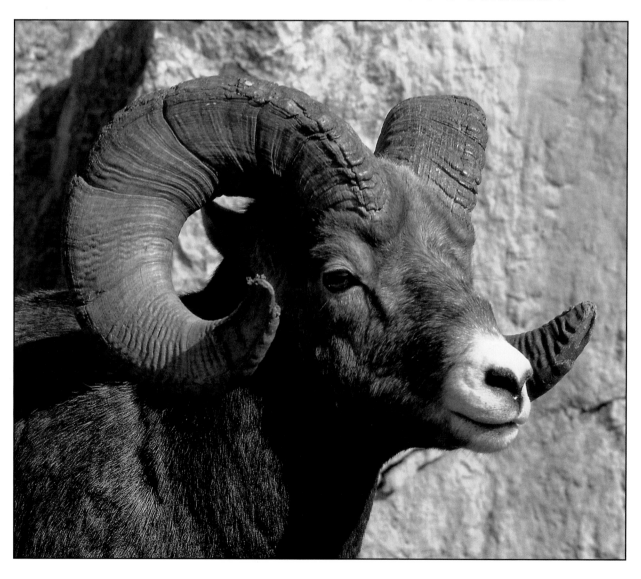

Mount Assiniboine

Mount Assiniboine was named for a native tribe of the Sioux confederation, locally known as the Stoney. The literal meaning of Assiniboine is "those who cook by placing hot rocks in water." Most high elevations create their own weather, and this "Canadian Matterhorn" — higher than any mountain in either Banff National Park or Mount Assiniboine Provincial Park — is no exception.

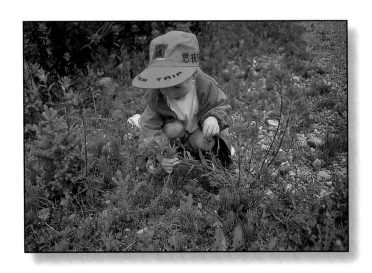

Child and Flowers

The Canadian Rockies inspire their visitors with the spirit of adventure. Rugged peaks, lush valleys and ample lakes exude the strength and dignity that typify the alpine wilderness. This region touches the soul, lingering in the hearts of adventurers wherever they may travel.

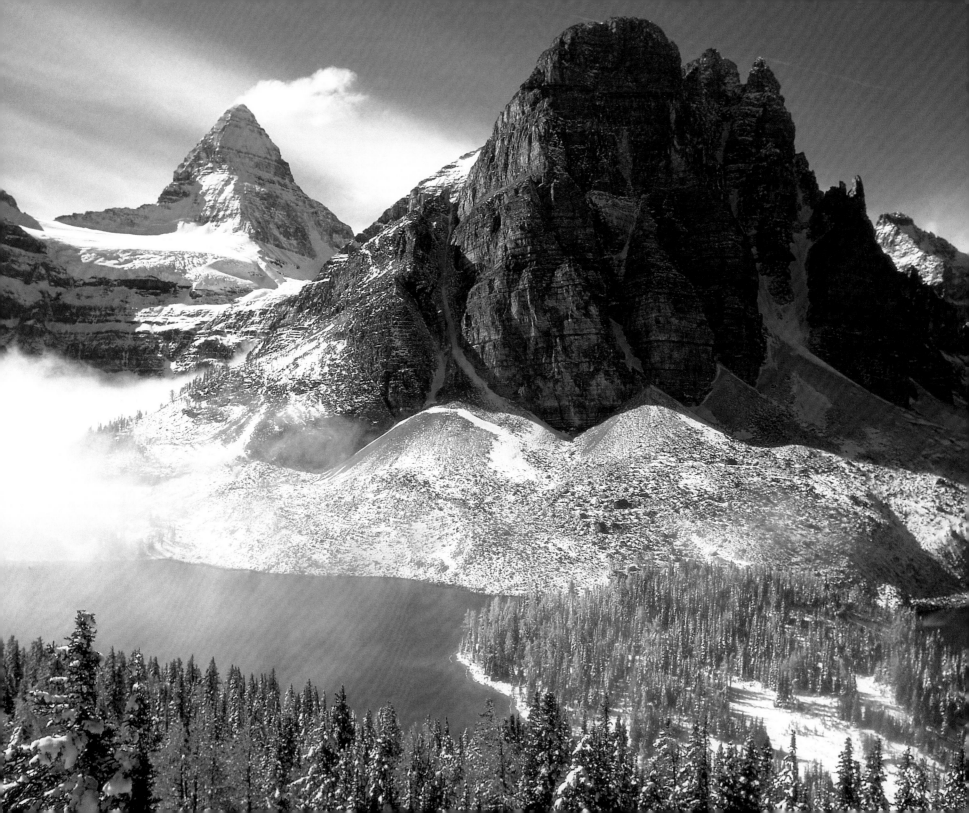

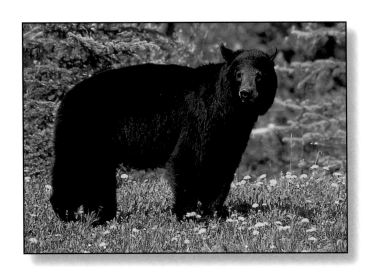

Black Bear

Waterton Lakes National Park

The mountains of Waterton Lakes National Park are upside down. The rock that comprises them originally rested in layers at the bottom of a shallow inland sea. When the mountains were formed, 1.5-billion-year-old sediment came to rest on top of much younger shales, leaving exposed some of the Rockies' oldest visible rock. This unique area supports a great variety of wildlife, and over half the flora that grow in Alberta can be found there.

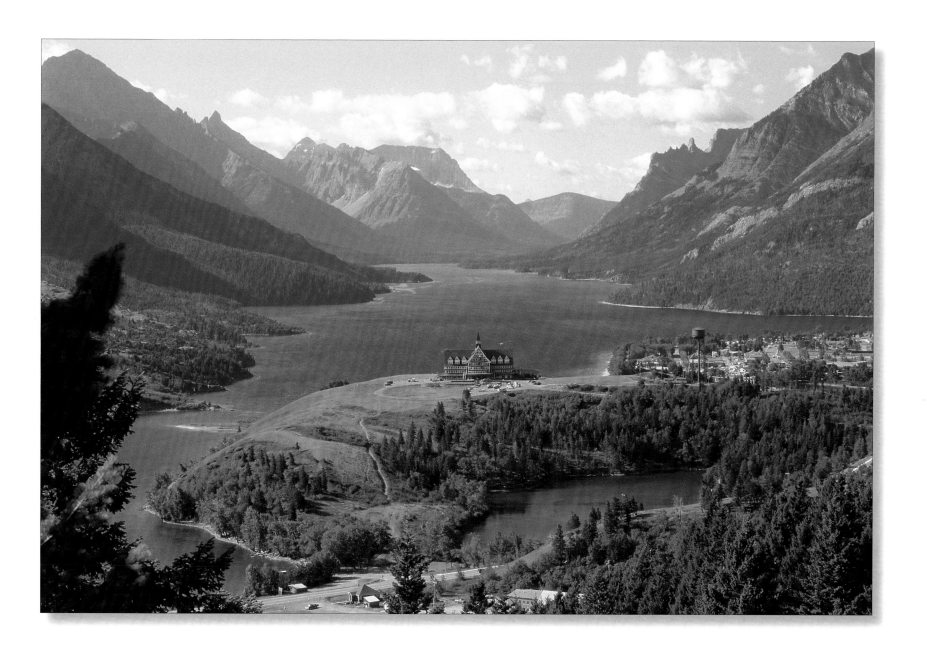

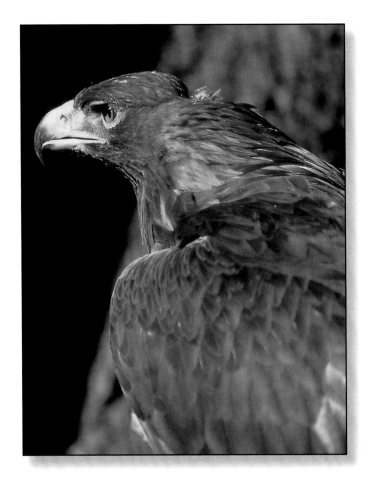

Golden Eagle

Mount Kidd

Stuart Kidd, the man for whom this main range mountain is named, was an Alberta rancher and trading post operator. On the north shoulder of Mount Kidd's mass of thick limestone layers perches a tiny fire lookout that offers a commanding view of Kananaskis Village. Seen from the journey south beyond Kananaskis Village or north past Galatea Creek, this mountain is among the most impressive in the valley.

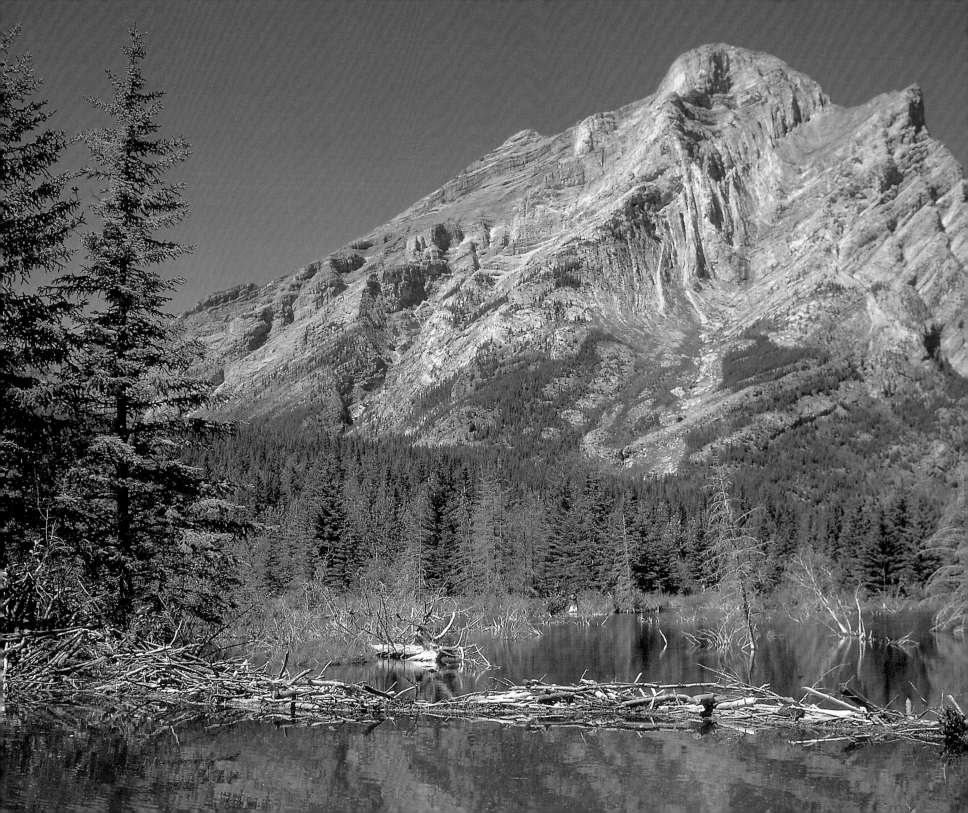

Wild Rose

Three Sisters

Originally called the Three Nuns, the Three Sisters are unofficially named Faith, Hope, and Charity by locals. These mountains have been Canmore's trademark since the late nineteenth century, when it was a small mining community. No longer regarded as a site rich in raw materials, Canmore's rugged beauty now attracts international recognition.

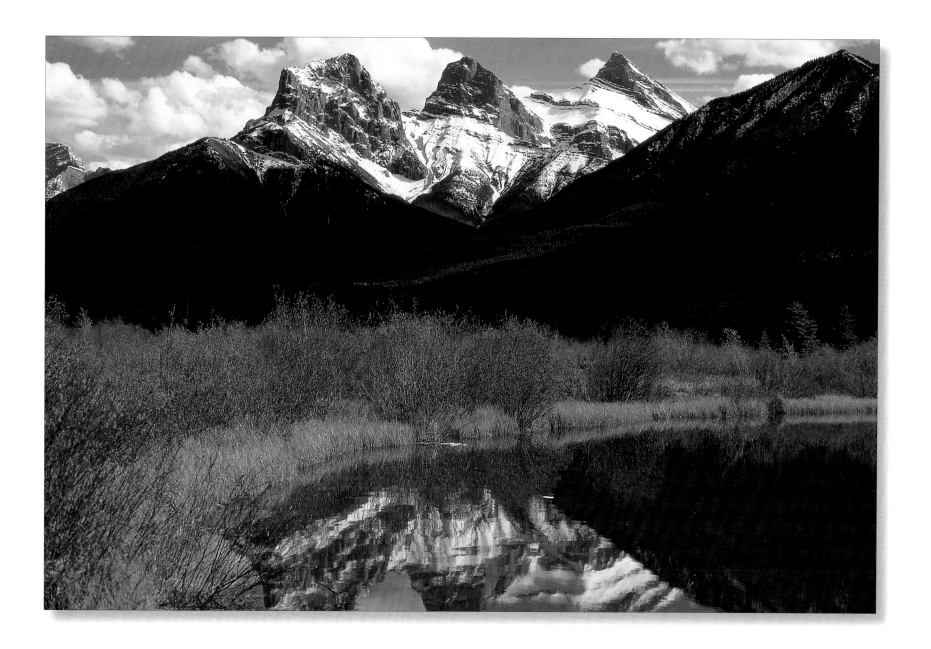

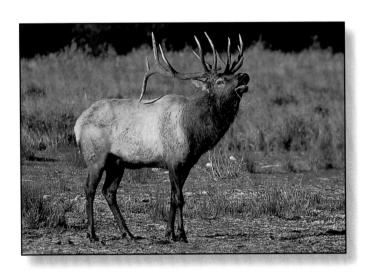

Elk

Mount Rundle

In 1874, the Methodist minister who became this mountain's namesake came to the Bow Valley to preach to Stoney natives near Banff. Mount Rundle is one of Banff's best-known landmarks; its imposing height (9,338 feet) makes it a peak to which ambitious climbers of ice and rock aspire.

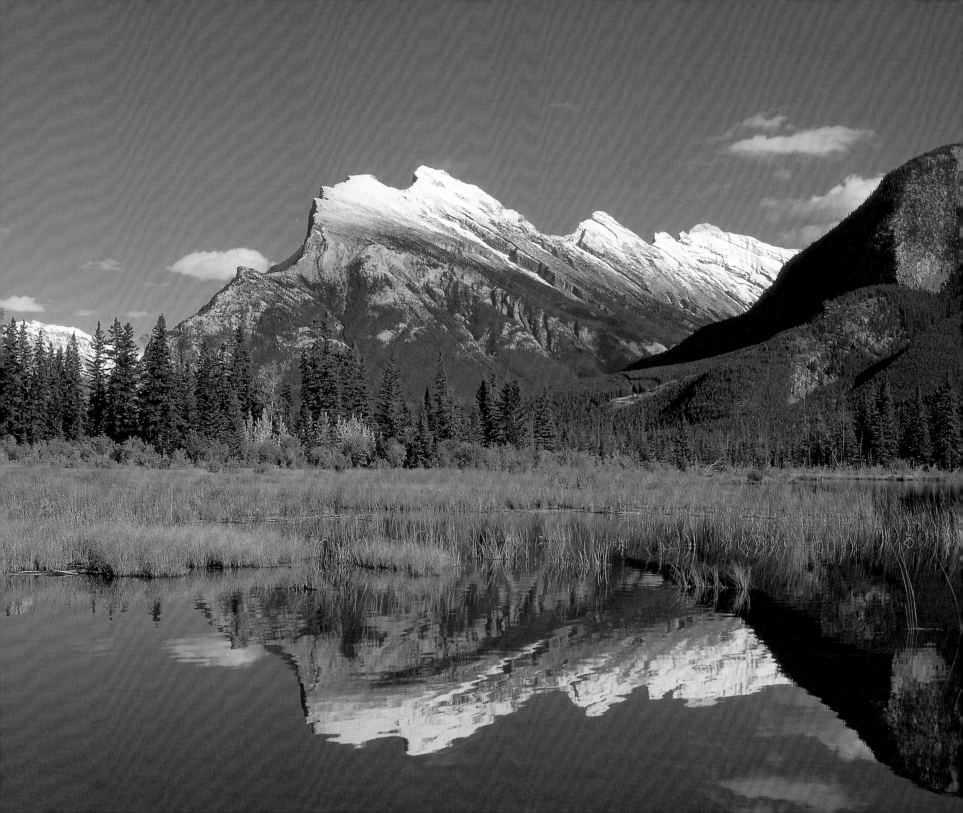

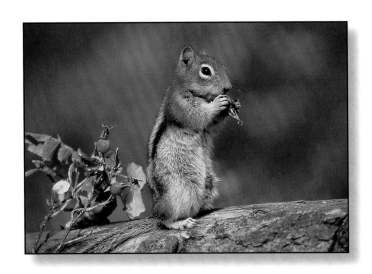

Golden Mantled Squirrel

Cascade Mountain

In many ways, Cascade Mountain is an emblem of Banff's metamorphosis over the last century. Between 1903 and 1922, 55 kilometres of coal tunnels were excavated from the base of Cascade Mountain, and a mining town called Bankhead flourished there. Today, the frozen waterfalls of Cascade Mountain are a veritable playground for ice climbers in the winter, while the mountain's slopes are a challenge for rock climbers in the summer.

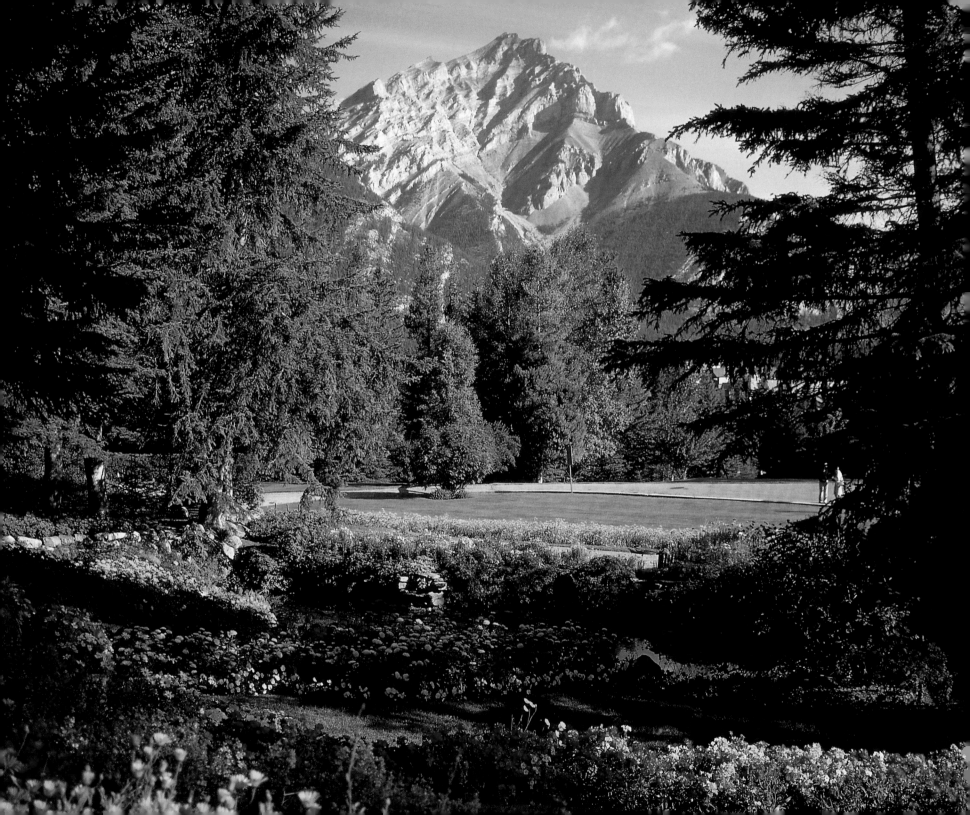

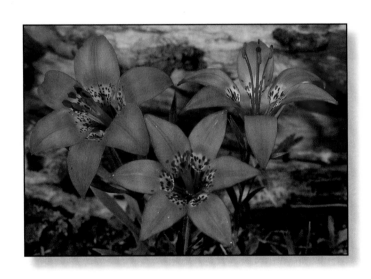

Red Wood Lily

Bow Falls

The headwaters of the glacier-fed Bow River are above Bow Lake, at the Wapta Icefield. The river winds its way calmly through the valley toward its dramatic tumble over Bow Falls. A dull roar can be heard from the footpath that follows the river, growing ever louder as one approaches the falls.

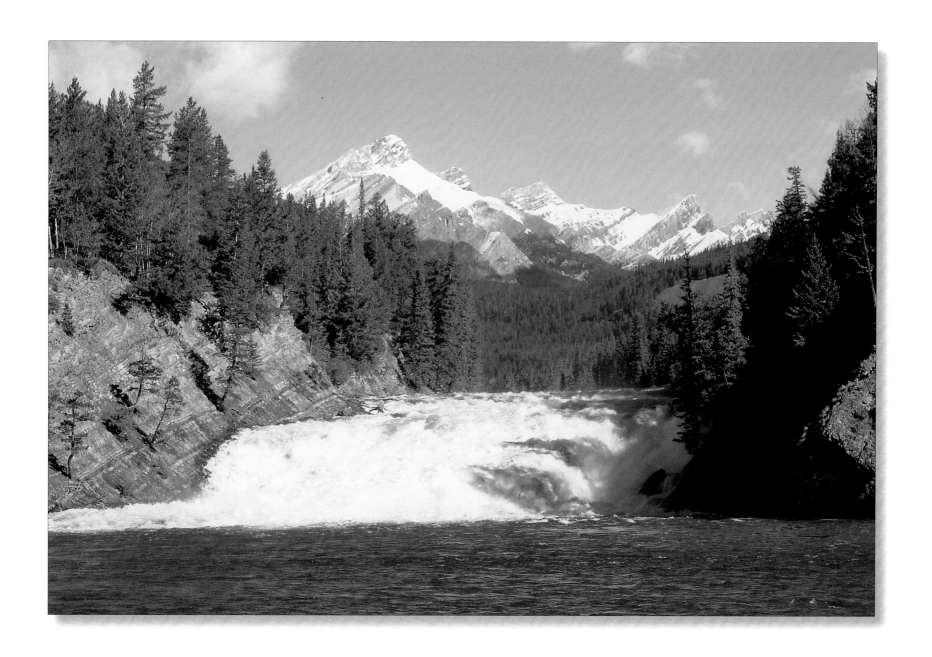

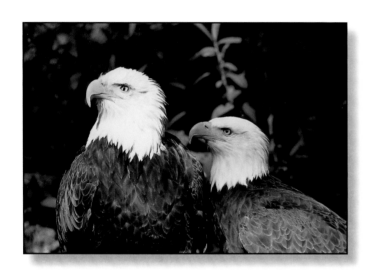

Bald Eagles

Banff Springs Hotel

William Cornelius Van Horne, general manager of the Canadian Pacific Railway (CPR), envisioned a luxurious hotel in the heart of the Rockies that would attract visitors to the rugged wilderness. He commissioned Bruce Price to design it after the fashion of late Victorian architecture. When the hotel opened in 1888, it was the largest in the world. It has since expanded considerably; its world-famous golf course, fine restaurants and beautiful suites are evidence that Van Horne's vision has been realized.

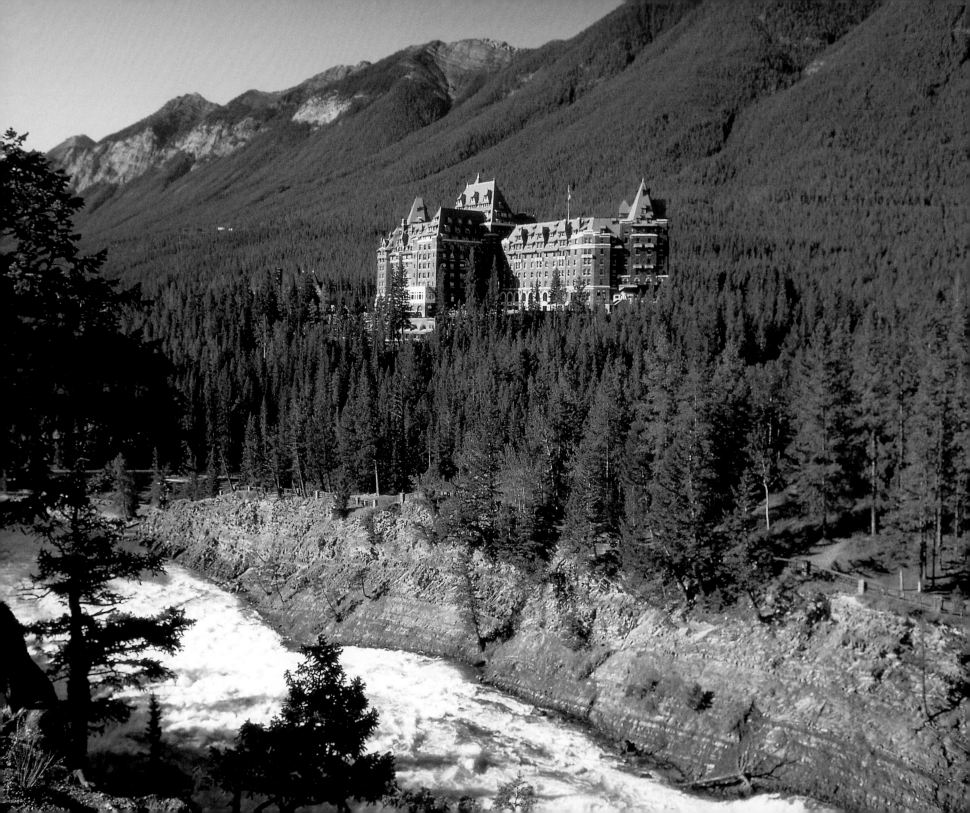

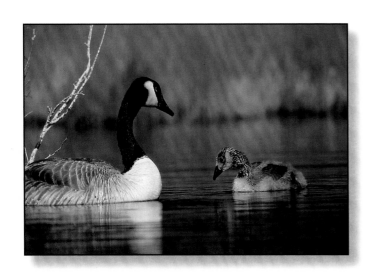

Canada Goose

Mount Rundle from Two Jack Lake

Located on the Minnewanka Loop, Two Jack Lake lies between Johnson Lake and the largest man-made lake in the park, Minnewanka. It was named after two men who lived and worked the area: Jack Stanley, who operated a boat concession on Lake Minnewanka, and Jack Watters, who worked for the mines in Bankhead. Both men must have frequented the shore of the waters that were named for them.

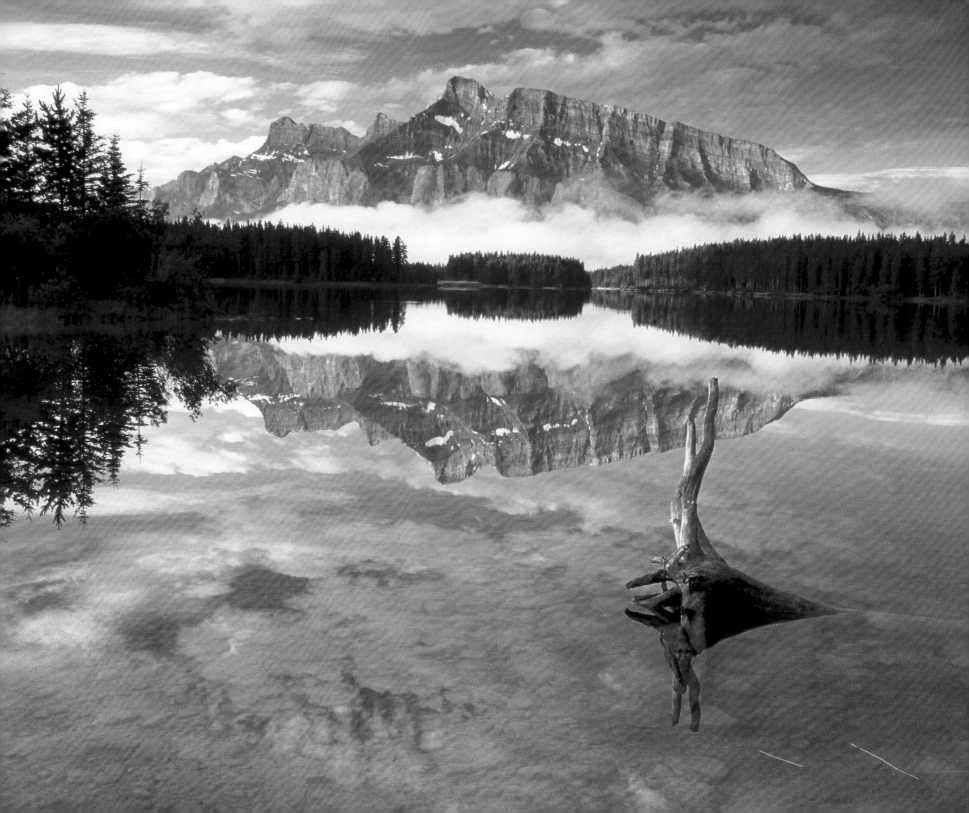

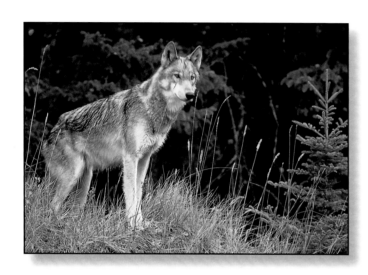

Wolf

Castle Mountain and Buttercups

Weak layers of shale that once separated more resistant limestone formations have eroded over the centuries, giving Castle Mountain the shape for which it is named. Between 1946 and 1979, this mountain's name was changed to Mount Eisenhower in honour of the American general who commanded the Allied forces in World War II. It was decided, however, that its original name was more appropriate. Castle Mountain's highest peak still bears the general's name.

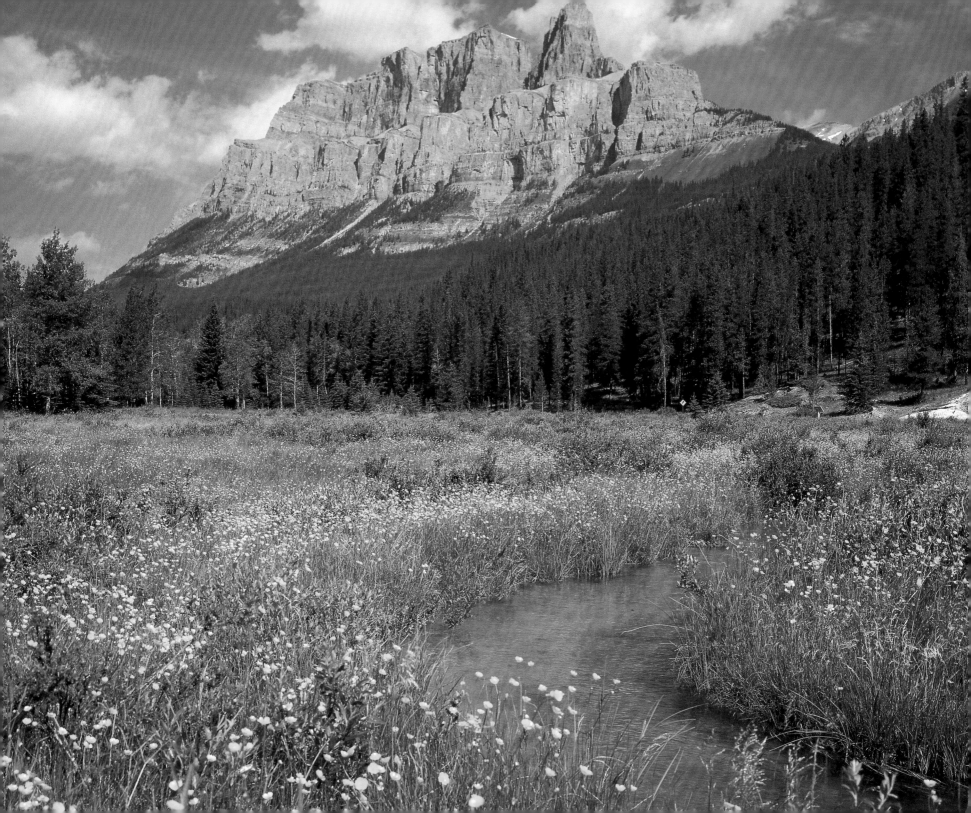

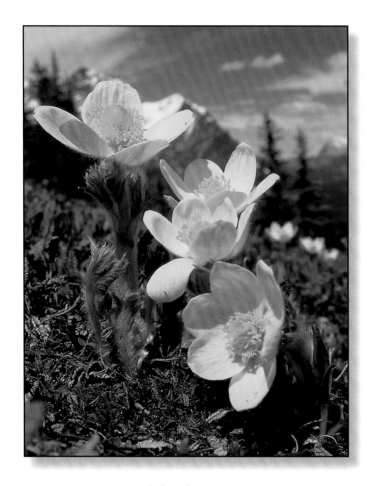

Globe Flowers

Two Bears

In Banff and Jasper national parks, grizzly bears outnumber black bears 2 to 1. Grizzlies are the largest and most powerful carnivores in the Rockies and have no natural enemies. Despite the grizzly's reputation as a ferocious hunter, almost 90 percent of its diet is vegetarian. It spends most of its time seeking food; during the berry crop, an adult grizzly will typically eat 200,000 buffalo berries per day.

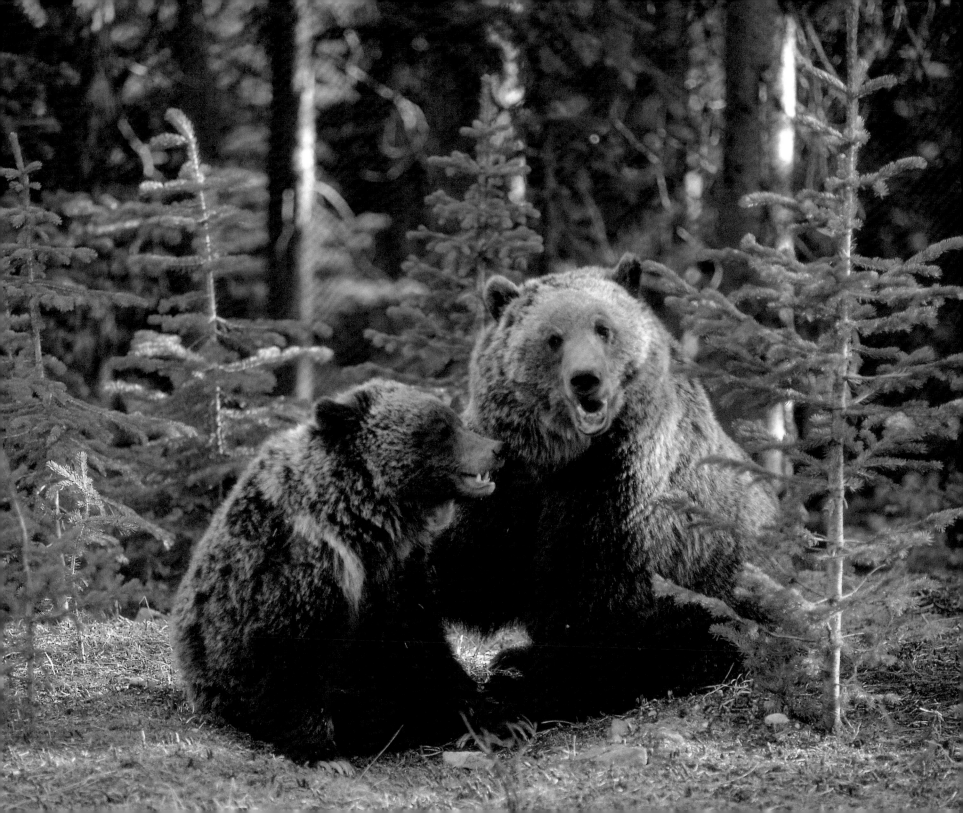

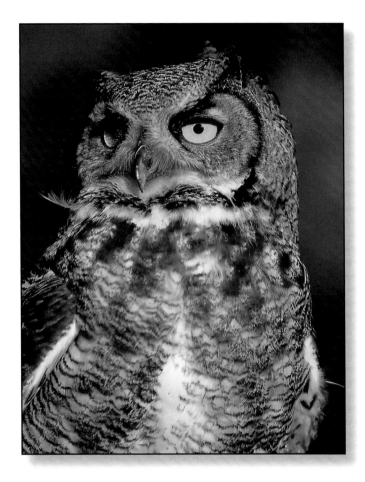

Grey Owl

Mount Temple

Standing 3,543 metres above sea level, Mount Temple is the largest peak in the Lake Louise area. In 1848, it was named after Sir Richard Temple, the man who led that year's British Association excursion party to the Rockies. Mount Temple's layered appearance makes it a castellated mountain. Like the rest of the Rockies, it has eroded considerably over the 120 million years since its formation.

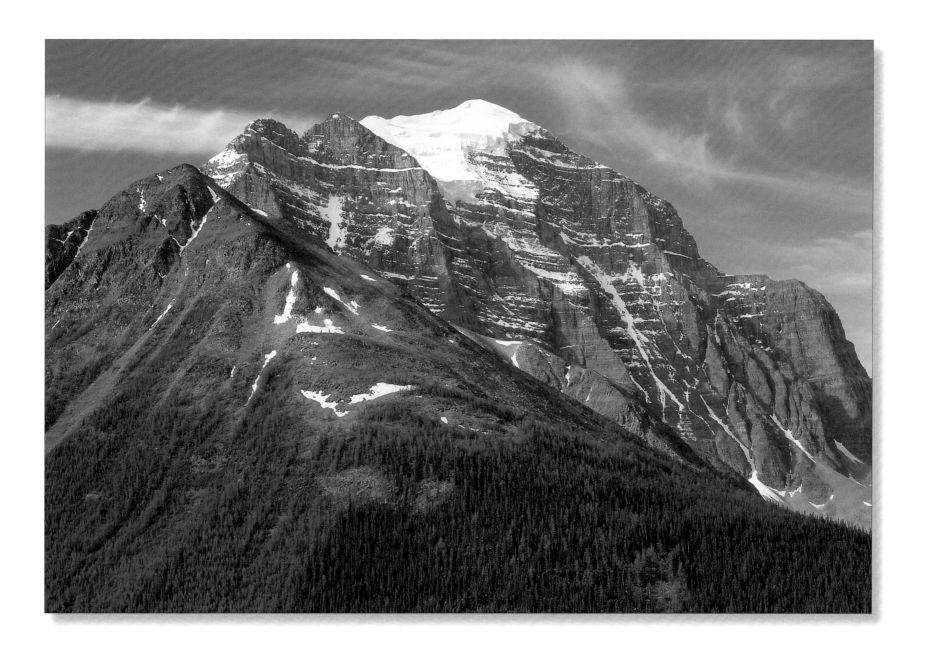

Alpine Meadow

Moraine Lake

Moraine Lake was originally thought to have been dammed by a glacial moraine in 1899, and so it was named. The lake is nestled in the Valley of the Ten Peaks, each of which was named in 1893 after the Stoney words for one through ten. Concealed from view on the north side of the limestone backdrop is Wenkchemna Glacier, the icy source that feeds Moraine Lake.

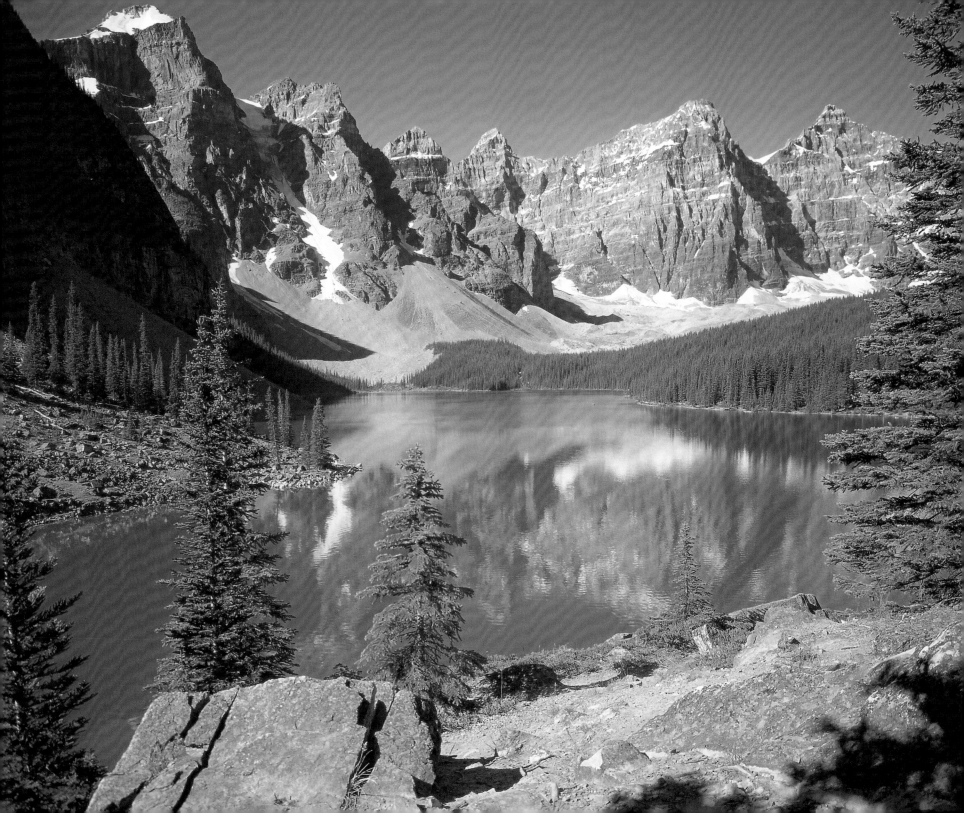

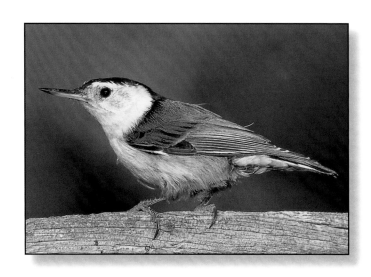

Nuthatch

Chateau Lake Louise

Originally built in 1820 to promote the railway line through the Rockies, the Chateau Lake Louise has blossomed over the last century from the tiny log cabin that was its forerunner. Today, the Chateau houses 1000 guests and attracts countless international travellers. In keeping with the spirit adventure that prevailed in early mountaineers, the Chateau's boathouse and stable offer alternative ways of exploring the area.

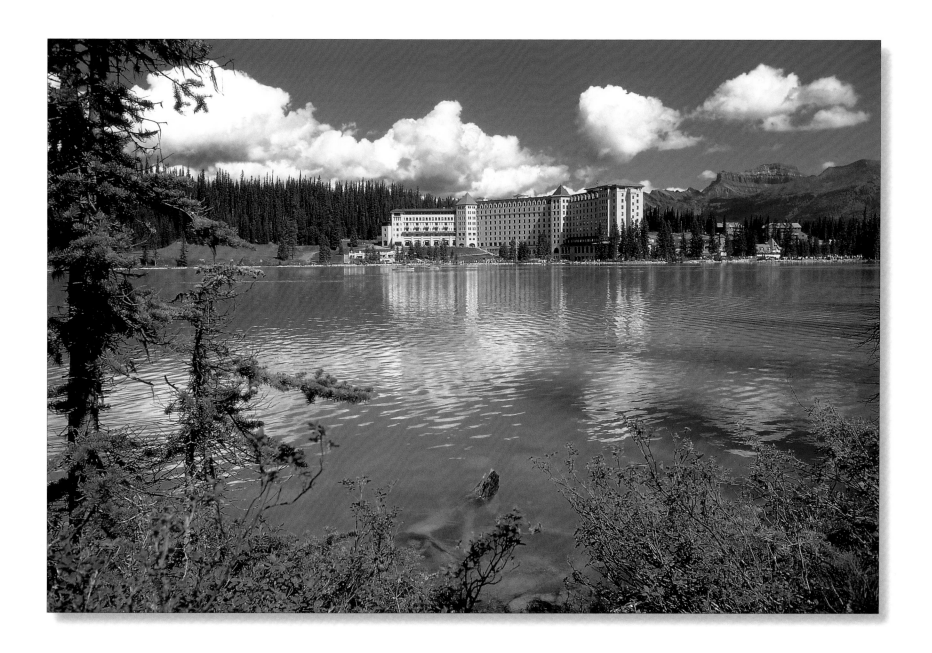

Poppies

Lake Louise

The glacier-laden Mount Victoria, which forms the backdrop to Lake Louise, was described by Stoney natives as "the big snow mountain above the lake of little fishes." An interpretive trail that begins in front of the Chateau leads to the teahouse below the glaciers. An alternative route leads to the tiny Mirror Lake and to Agnes Lake, which has a rustic teahouse of its own. The view of Lake Louise from either trail is a magnificent sight to behold.

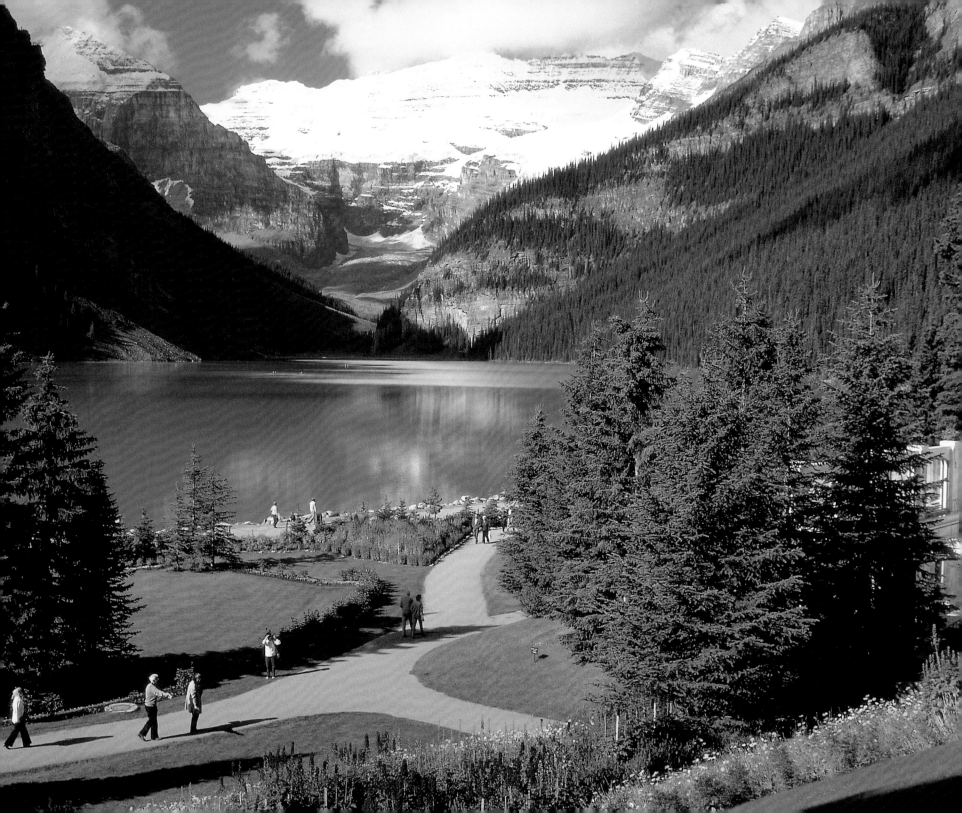

Columbia Ground Squirrel

Lake Louise

The town of Lake Louise was formerly known as Holt City. Its name was changed to Laggan by Lord Strathcona to honor a place of that name in Inverness, Scotland. In 1884, both the town and the lake were named Lake Louise, after Princess Louise Caroline Alberta, the fourth daughter of Queen Victoria (1848-1939).

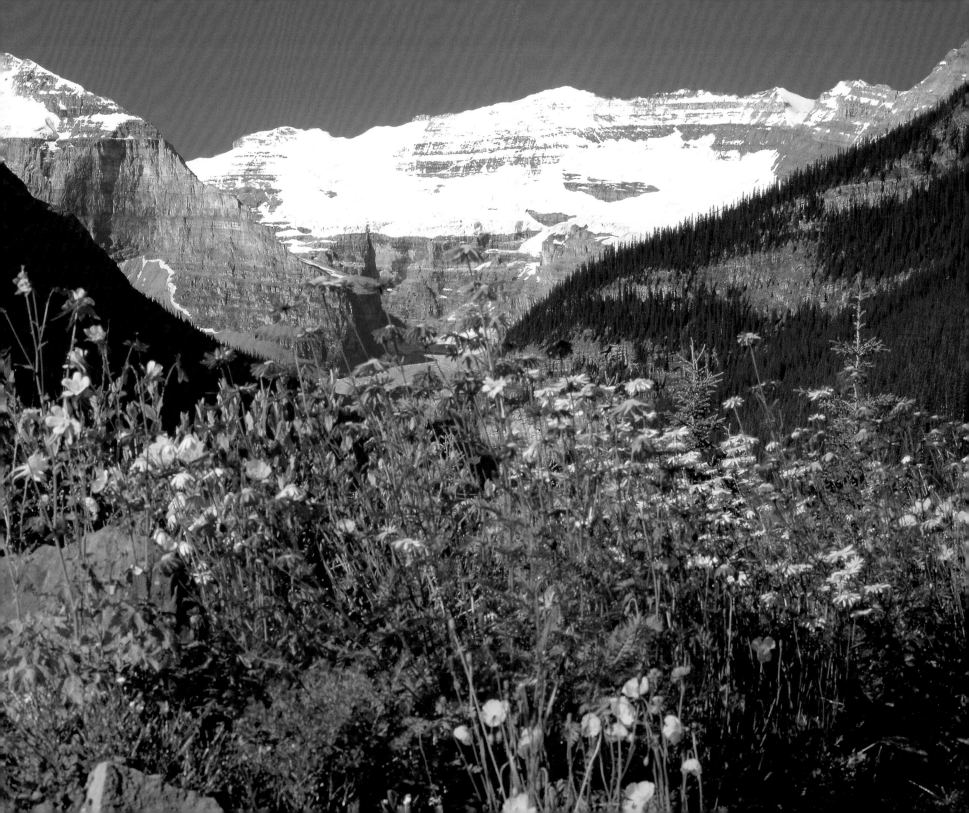

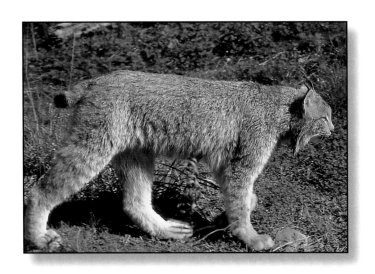

Lynx

Natural Bridge

The Kicking Horse River has eroded a narrow canyon through the weak shales in the bedrock. The river winds smoothly along its path until it meets Natural Bridge, a relatively resistant outcrop of limestone. Over the years, the river has forced its way through this obstacle. The limestone now bears a downward crack through which the river gushes. The "bridge" will grow ever wider as the constant flow of water wears it away.

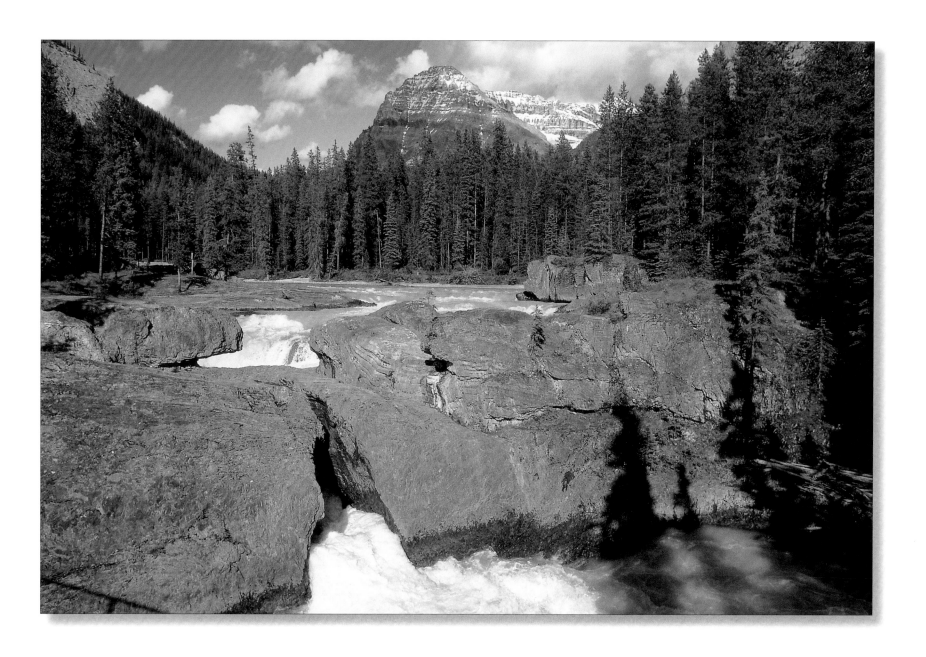

Crocus

Emerald Lake

Emerald Lake, the largest in Yoho National Park, was formed when a glacier scoured out a hollow and then glacial meltwater collected. The rock rubble deposited in the process formed a moraine on which Emerald Lake Lodge is constructed. The lodge is a popular retreat for hikers, cross-country skiers, sport fishermen and boaters. From it, a trail leads to the spectacular glacial amphitheatre of Emerald Basin.

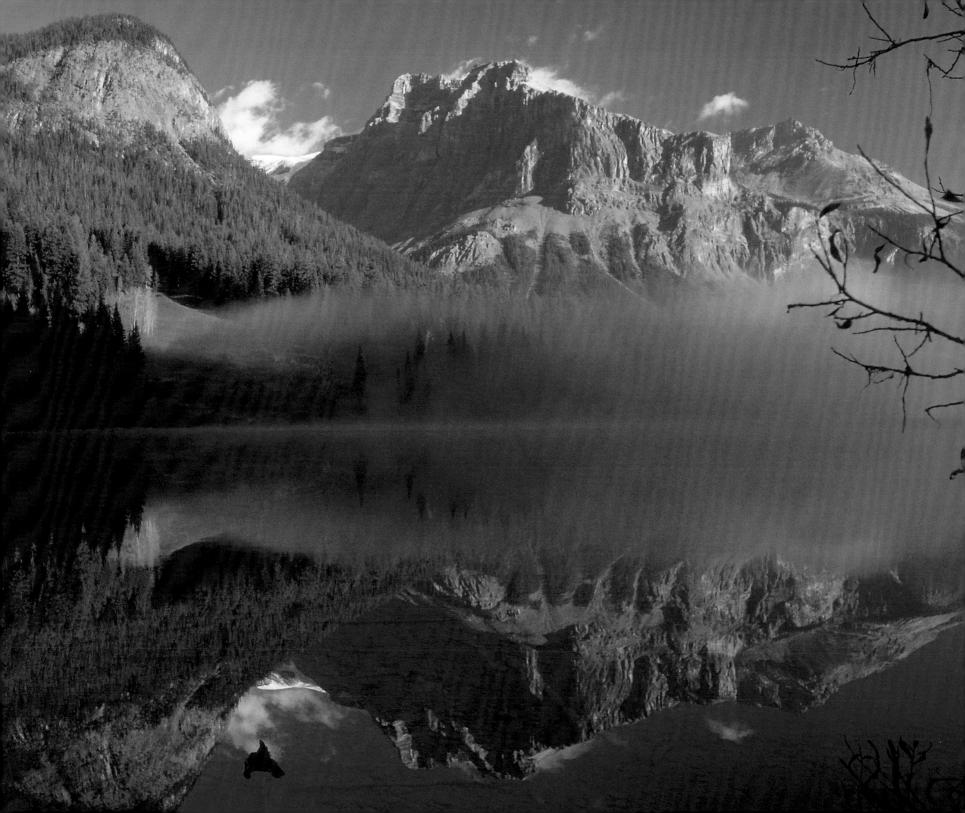

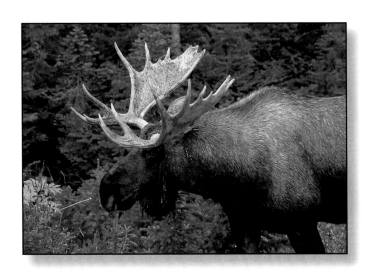

Moose

Takakkaw Falls

In the Cree language, the way to say "it is magnificent" is *Takakkaw.* The falls of that name are fed by a lake at the base of Daly Glacier on Mount Balfour. While the force of the cascade is considerable in the summer months, the glacial meltwater is reduced to a trickle when the lake freezes in the winter.

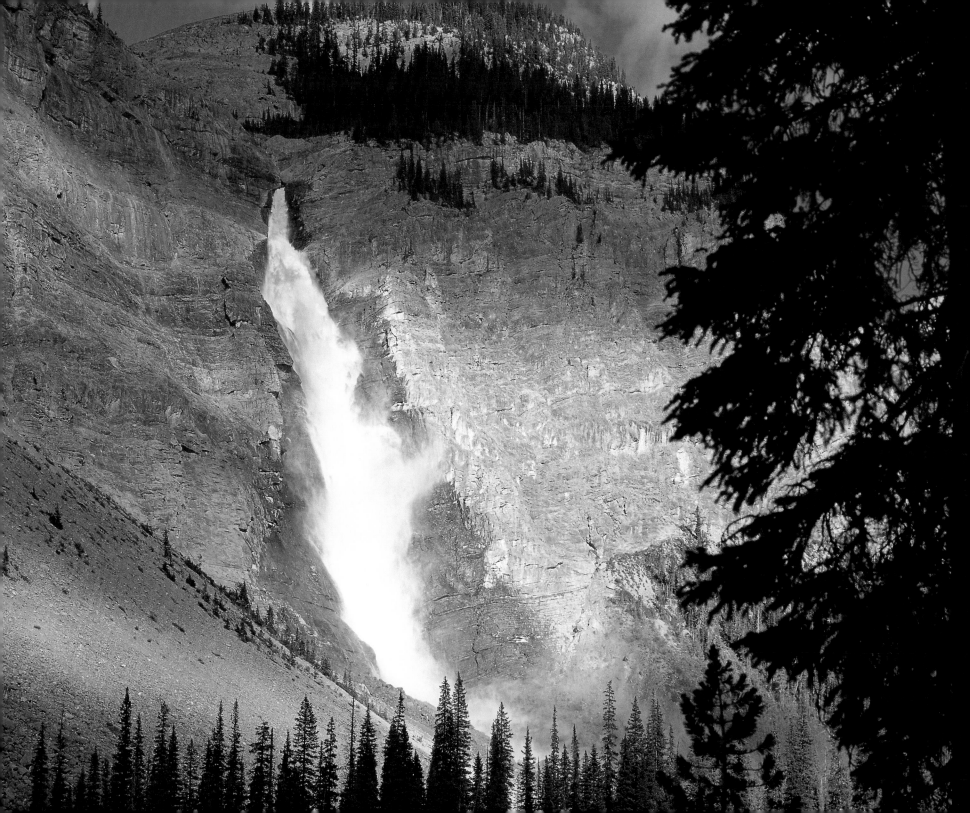

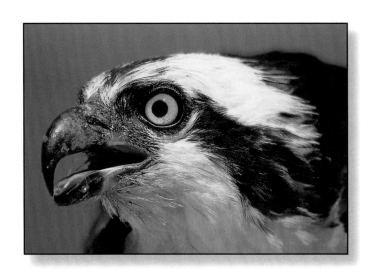

Osprey

Crowfoot Glacier

The steep upper cliffs of Crowfoot Glacier act as a snow fence that deposits snow on the lower slopes of the mountain. On the sheltered side of Crowfoot Mountain, this snow turns to glacial ice. When the glacier advances with the force of gravity, the rock rubble it carries with it etches out the mountain's features, leaving a record of the glacier's passing.

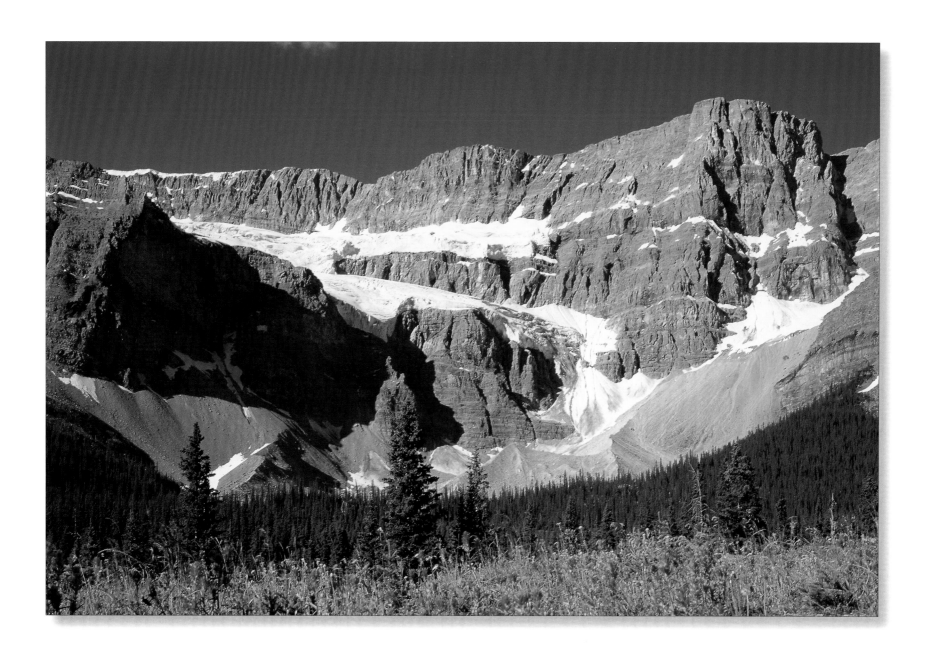

Indian Paintbrush

Bow Lake

Glacial meltwater feeds Bow Lake, the source of the Bow River. Because of the abundance of saplings that grow on the river's banks, the natives' name for the river means "place from which hunting bows are gathered." Thus the name "Bow" spread to the river, lake and falls. Today, the lovely Num-ti-Jah Lodge stands on the lakeshore.

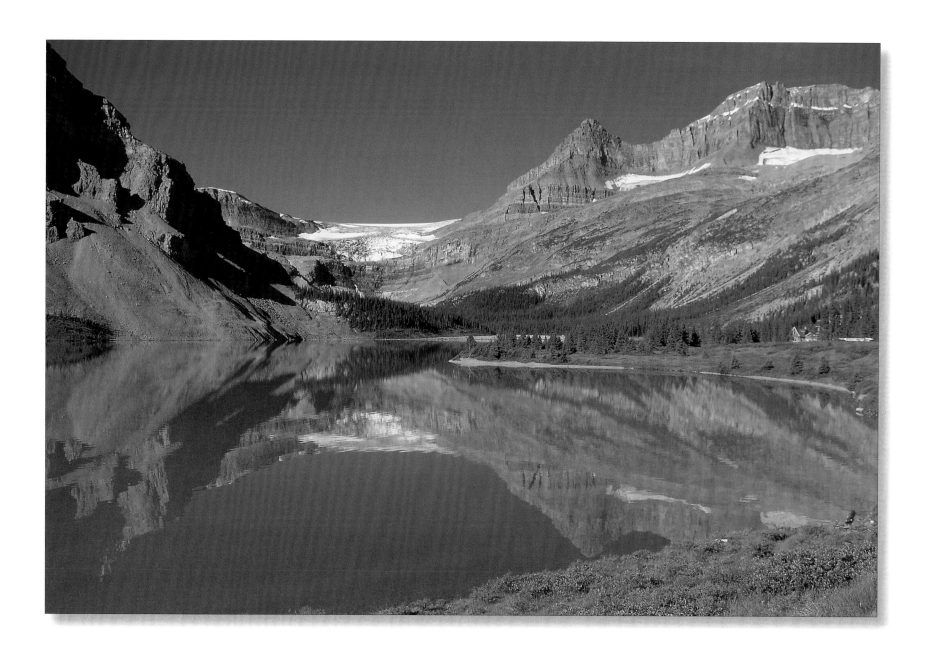

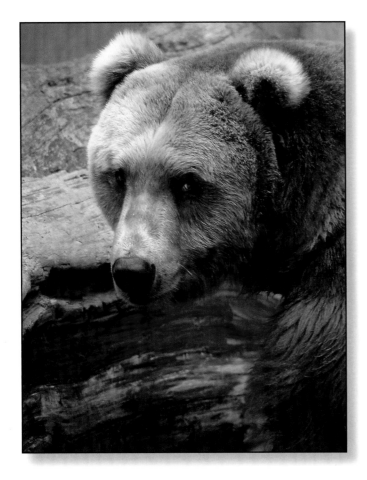

Grizzly

Peyto Lake

"**W**ild Bill" Peyto was a pioneer trail guide, outfitter and park warden who would steal away to this lake after a day's work for a few moments' solitude. Named for him, Peyto Lake is the fifth largest lake in Banff National Park. The short, paved Bow Summit Trail leads to the Peyto Lake Overlook — one of the best-known viewpoints in Banff National Park.

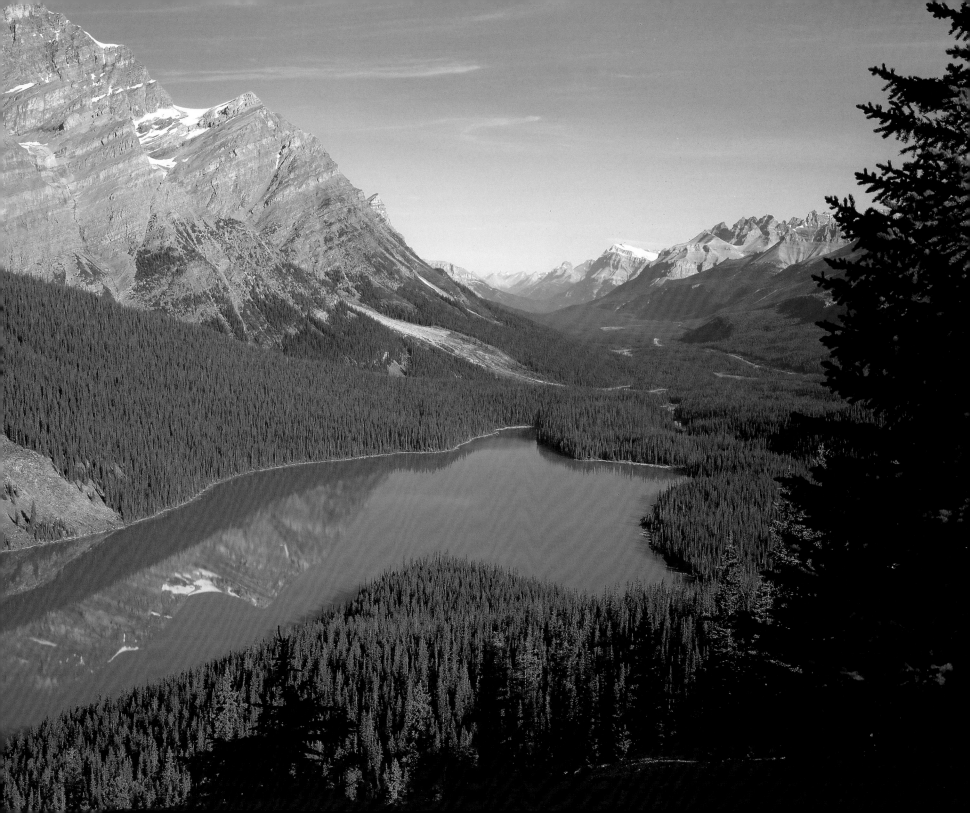

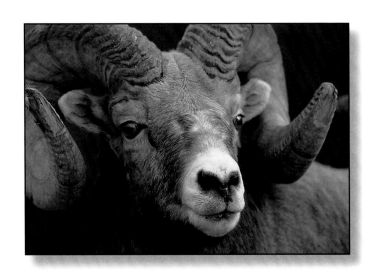

Bighorn Portrait

Athabasca Glacier

Of all the glaciers in North America, Athabasca is the most accessible. It is close to the Icefields Parkway and features the Forefield Trail, on which visitors can venture up to the glacial ice for a closer look. Very little of the snow that falls on the glacier melts. As a result, the air circulating above the icefields is chilly.

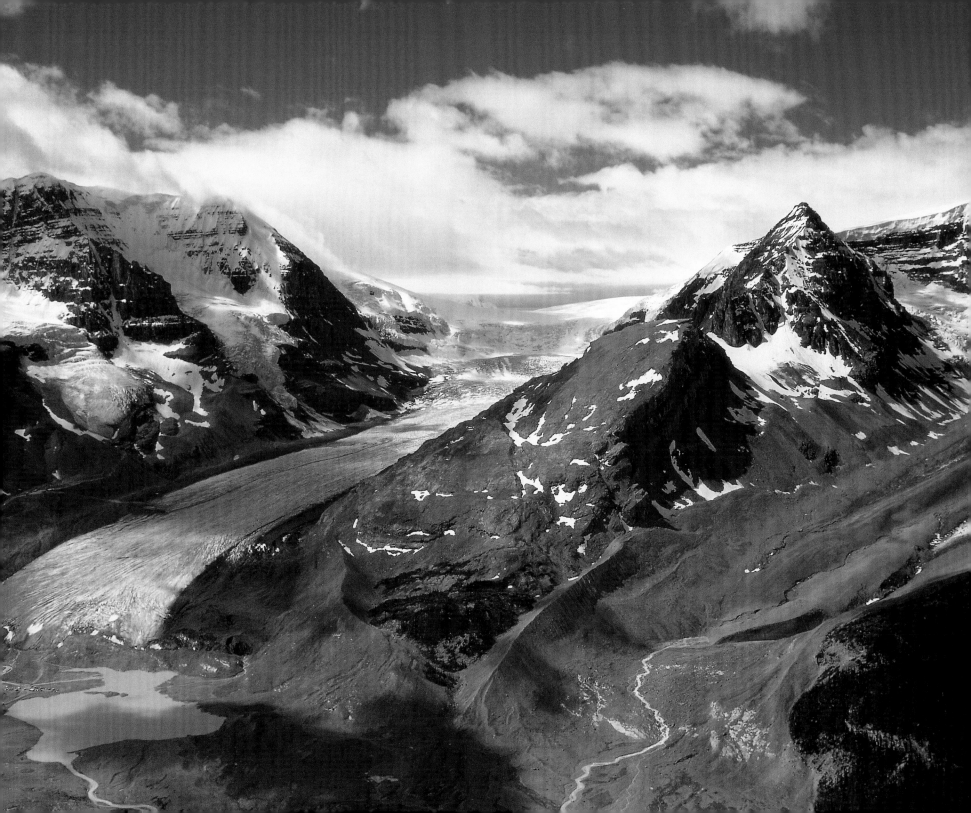

Moss Campion

Athabasca (detail)

Athabasca Glacier is one of eight outlet valley glaciers that flow from the Columbia Icefields. In the course of time, glacial movement forms vast cracks or crevasses in the ice. This glacial movement, although imperceptible in the course of a day, has been considerable. Athabasca is currently receding at a rate of one to three metres per year.

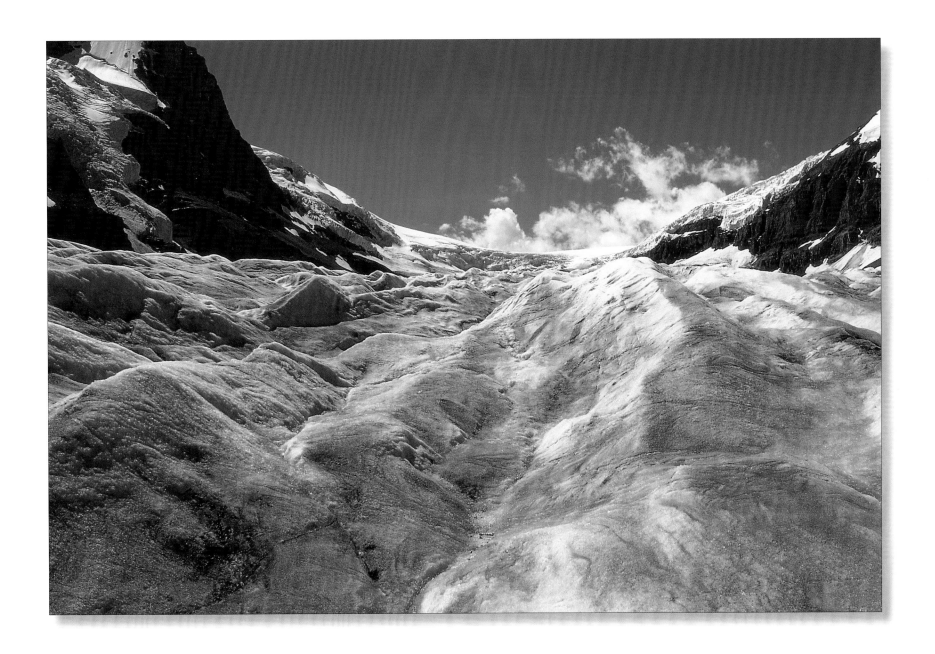

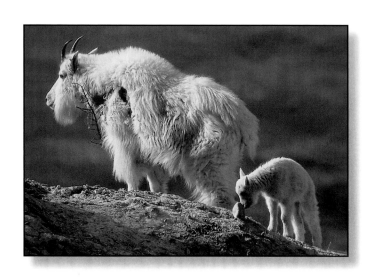

Goats

Athabasca Falls

When Athabasca Glacier carved out the valley, it failed to erode the resistant step of Gog quartzite over which the falls cascade. This hump in the bedrock continues to defy the steady rush of water that will eventually wear it down. The churning force of the falls testifies that while the wilderness may at times seem serene, it is anything but tame.

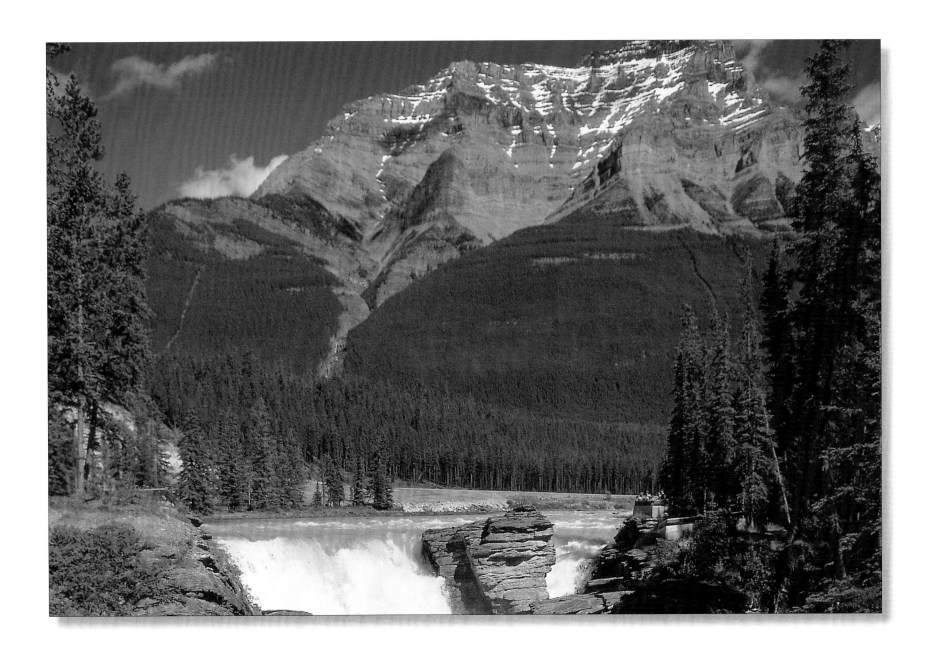

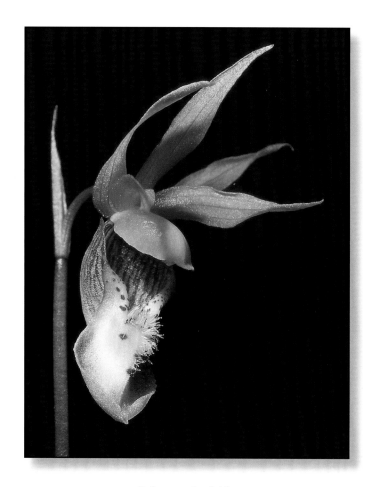

Calypso Orchid

Mount Edith Cavell

Edith Louisa Cavell, the English nurse for whom this mountain is named, was a martyred war hero. When German forces discovered that she had assisted the escape of Allied prisoners during World War I, she was executed. From the Path of the Glacier Trail that begins at the mountain's base, the marks of a recent glacial retreat can be seen, providing a clear view of the process by which the lakes and valleys of the Canadian Rockies were formed.

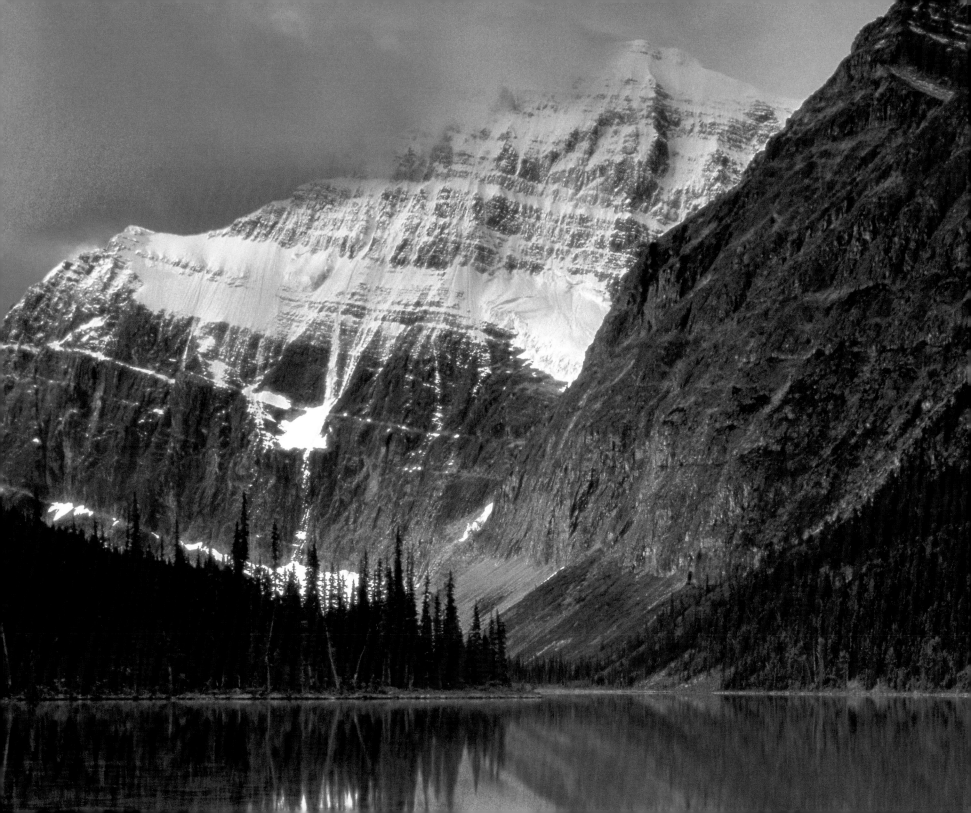

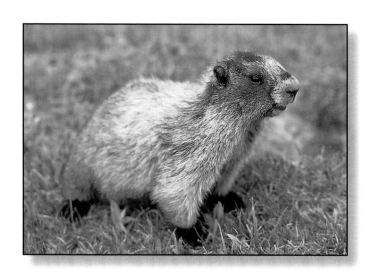

Hoary Marmot

Jasper and Tramway

The largest of the Rocky Mountain parks, Jasper features almost 1,000 kilometres of maintained trails. The Jasper Tramway climbs 935 metres over montane, subalpine and alpine ecoregions. Its upper terminal affords a spectacular view of the Athabasca and Miette River valleys, the surrounding mountain ranges, and the multitude of lakes for which Jasper is famous.

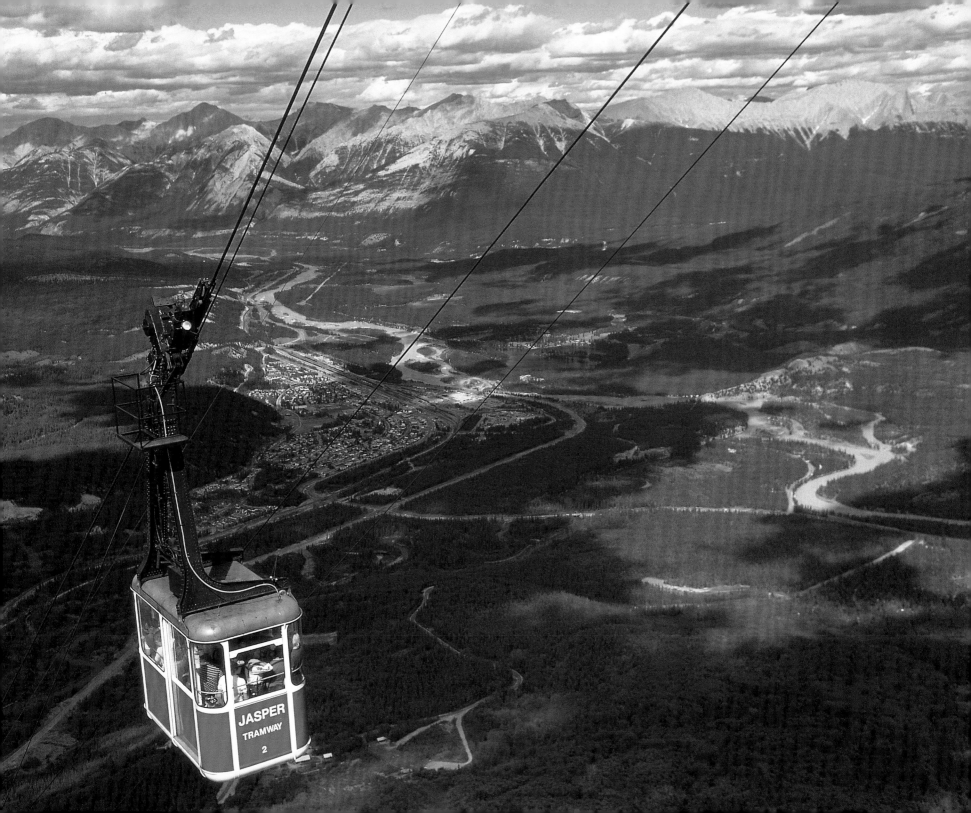

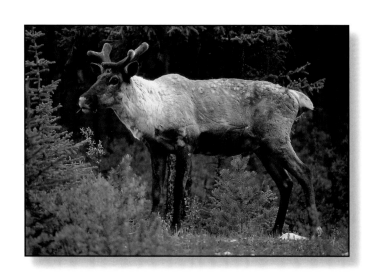

Caribou

Pyramid Lake

The area surrounding Pyramid Lake is ideally suited to mountain sports and leisure activities. Its many trails, which wind through forests of aspen and lodgepole pine, are frequented by visitors on horseback. Boats, too, can be rented at the lake. A leisurely paddle along the shoreline reveals the abundance of animal and plant life supported by this region.

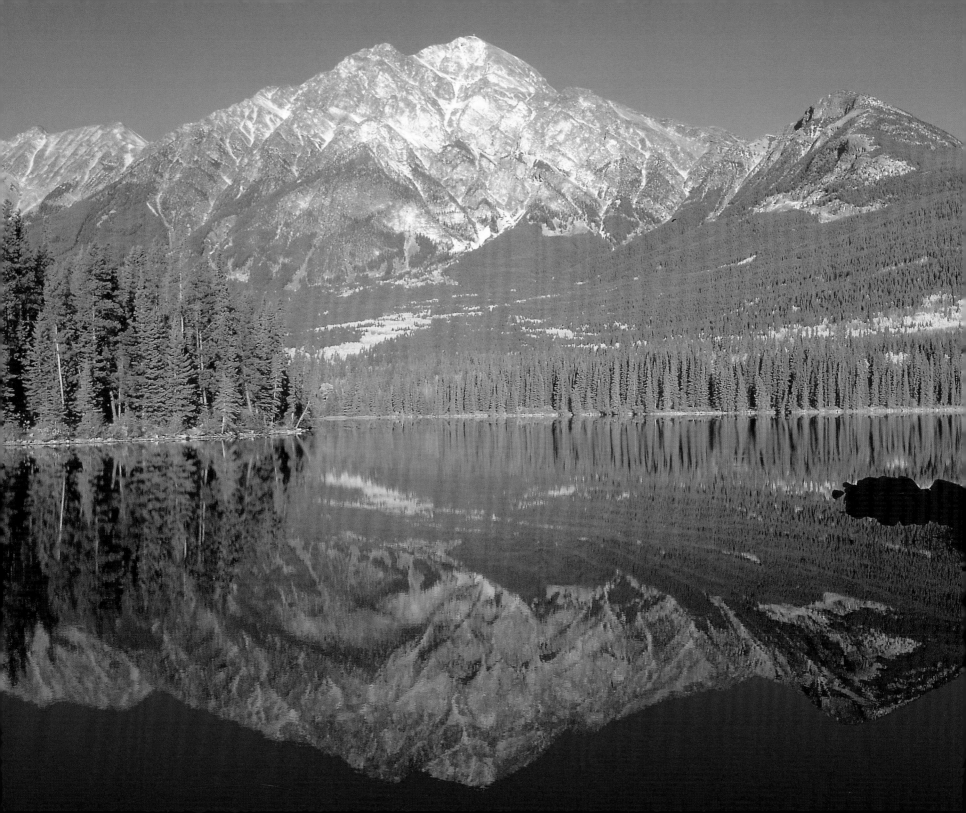

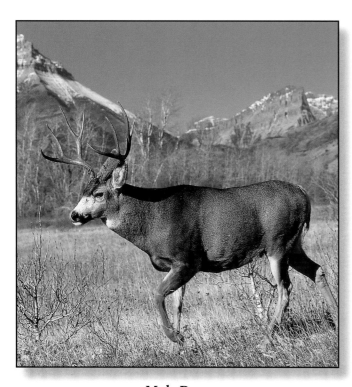

Mule Deer

Jasper Park Lodge

The current Jasper Park Lodge is a far cry from its forerunner, which was built to accommodate the swelling tide of visitors to Jasper after the railway was built through the Rockies. Originally, a "tent city" was erected on the shore of Lac Beauvert. The lake's French name refers to its beautiful green colour. The finely ground "rock flour" that rests on the lakebed reflects light in a particular way, making the water appear aquamarine.

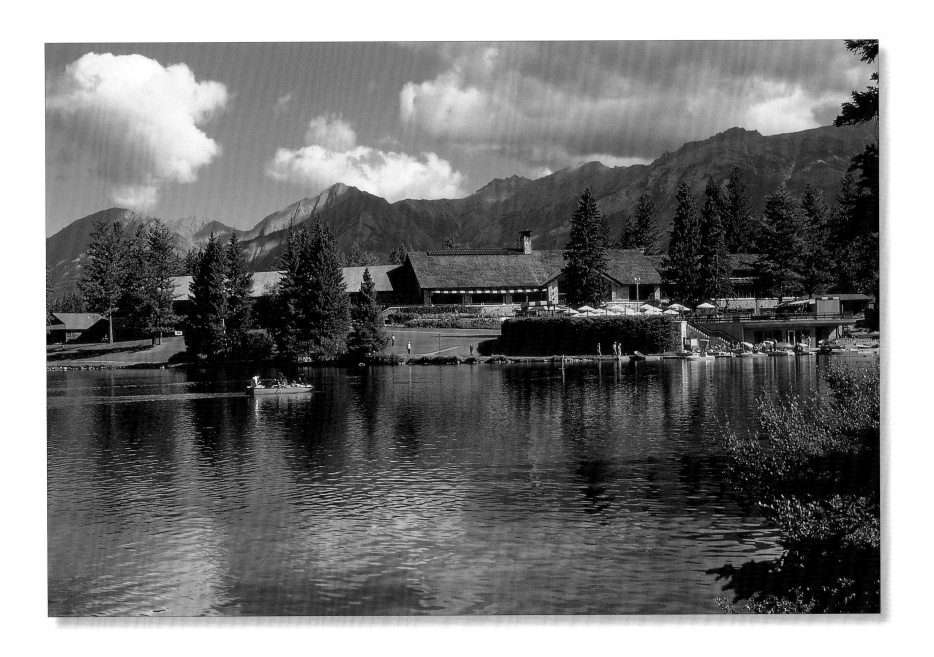

Columbine

Maligne Lake

Samson Beaver, a Stoney chief who recalled having journeyed to *Chaba Imne* or "Beaver Lake" as a child, sketched out a map of this distant memory. Using it in 1908 to retrace his steps, Philadelphia Quaker and avid geographer Mary Schäffer rediscovered what turned out to be the largest natural lake in North America. Its current name — Maligne — means "wicked," and was used by a Belgian missionary to describe the treacherous river that flows from the glacier-fed lake.

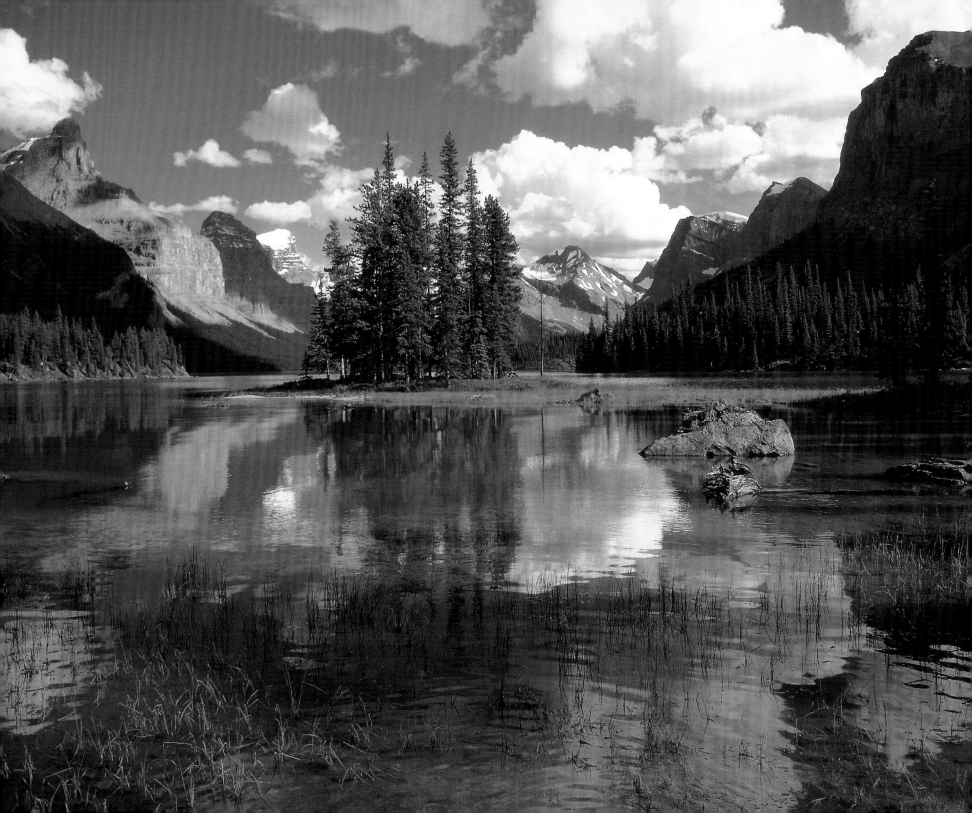

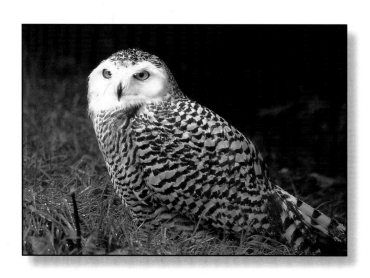

Snowy Owl

Mount Robson

Standing 3,955 metres above sea level, Mount Robson is easily the highest peak in the Canadian Rockies. Despite its striking immensity, it keeps its treasures well hidden. Only the hardy backpacker en route to the north side will discover that Robson holds one of the most spectacular glacier systems in the Rockies.

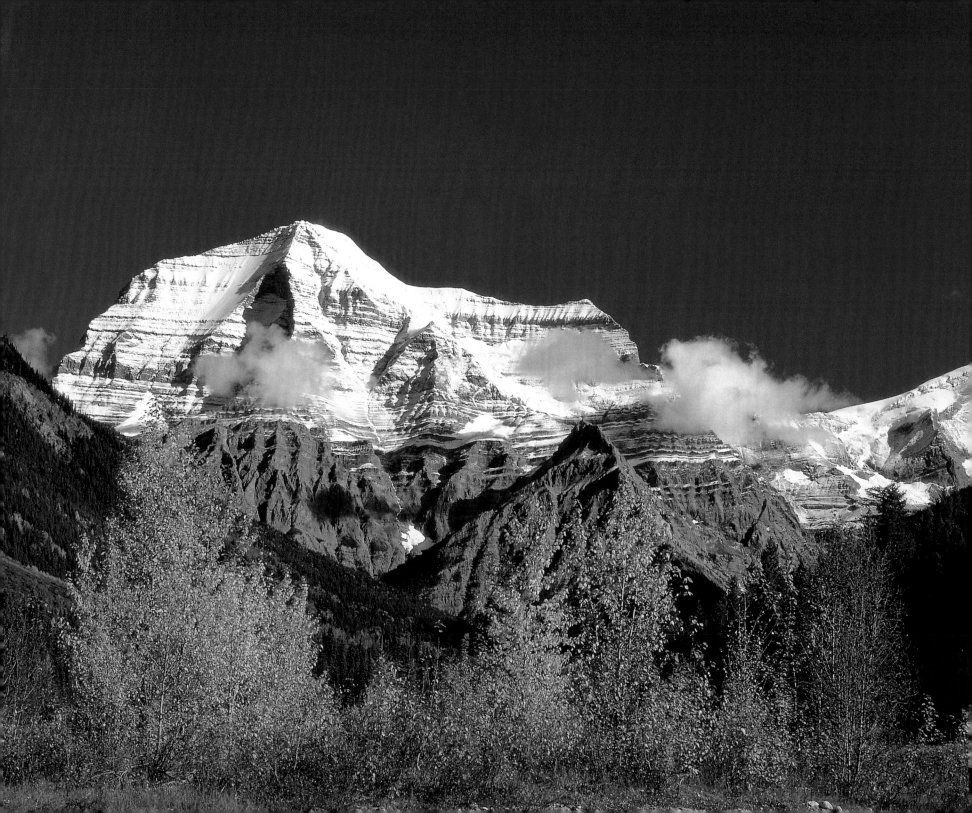

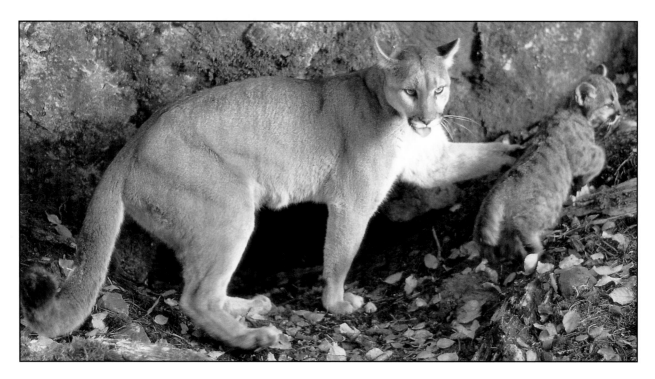

Rocky Mountain Books
www.rmbooks.com

Photographers: Carole Harmon, Don Harmon, Stephen Hutchings, Dennis & Esther Schmidt, Douglas Leighton, Lee Simmons
Photo Page 1: Bighorn sheep
Photo above: Cougar and cougar kittens

This book was produced using FSC®-certified, acid-free paper, processed chlorine-free and printed with vegetable-based inks.

Printed in Canada

Library and Archives Canada Cataloguing in Publication

Grobler, Sabrina, 1972-
 The Canadian Rockies : a complete photographic portrait / Sabrina Grobler. — 1st Rocky Mountain Books ed.

ISBN 978-1-897522-28-8 (pbk.)

 1. Rocky Mountains, Canadian (B.C. and Alta.)—Pictorial works. 2. Wildflowers—Rocky Mountains, Canadian (B.C. and Alta.)—Pictorial works. 3. Animals—Rocky Mountains, Canadian (B.C. and Alta.)—Pictorial works.
I. Title.

FC219.G763 2009 917.110022'2 C2008-907367-3

Rocky Mountain Books acknowledges the financial support for its publishing program from the Government of Canada through the Canada Book Fund (CBF) and the Canada Council for the Arts, and from the province of British Columbia through the British Columbia Arts Council and the Book Publishing Tax Credit.

 Canadian Heritage Patrimoine canadien

 Canada Council for the Arts Conseil des Arts du Canada

 BRITISH COLUMBIA ARTS COUNCIL
Supported by the Province of British Columbia